# don't move the muffin tins:
# a hands-off guide to art for the young child

by

bev
bos

illustrations by m. victoria cochran
photographs by david burton

turn-the-page press, inc.

Edited and designed by Kay Glowes
Cover design by Bryce Camp

Published by arrangement with The Burton Gallery.

First four printings, April, 1978 to September, 1981.
First Turn the Page Press printing, September, 1982.

Library of Congress Catalog Card Number: 78-53276.
ISBN: 0-931540-00-3

Turn-the-Page Press, Inc.
Roseville, California

For workshop and speaking engagement information write to:

Bev Bos
c/o TURN-THE-PAGE PRESS, INC.
203 Baldwin Avenue
Roseville, CA 95678

# contents

# preface

I have written this book for parents, for teachers, for people who care about children. My focus here is art for the young child—two to five years—but much of this art has been successfully used in workshops with older children and even with adults.

The art ideas in this book are not my inventions, nor are they anyone else's. All of this art has been used, in one form or another, for a very long time. My purpose in writing this book is not to provide novelty, but to inspire you to develop a sense of the child in your thinking about art and to carry that sense into your own programs. I've developed my own art program by searching, listening, and reading. More important than just following my suggestions is your being moved by the book to seek new ideas, to stay in touch with other parents and teachers in thinking about art, and to expand your own horizons and the art horizons of children.

Observing the joy of the children at our school as they create has made me want that joy for all children, and that is my principal reason for writing this book. As I've written and thought about our children's creativity, however, I have come to realize other hopes I have for the book.

Many parents would like to help their children be creative, but have no idea where to begin; they fear, furthermore, that art will be just another expensive mess. If you are one of these parents, I hope this book will help you give your child art activities without demanding that you spend two or three hours a day cutting, gluing, and running to the store for supplies.

For those of you who are more experienced with children's art, I hope that this book may serve as a kind of emergency kit when you are having one of those times when nothing goes right. There are days—sometimes two or three in a row—when children are sick, husbands or wives are laid off, it's raining, or the roof is leaking—times, if you're a teacher, when there's not been a minute over the weekend to prepare for Monday morning. I hope this book will be a help on those occasions.

There is a still broader use I hope this book receives. In observing high school students, college students, older adults in my workshops, I have come to realize that most of them have never had any opportunity to do art.

I recently did a workshop at a local high school, asking at the beginning of class how many students felt they were creative, how many enjoyed art. Only one student of the twenty-five raised her hand, and she isn't a reliable sample because she is my

own child. Initially, the students were very apprehensive. By the end of the workshop, they were begging to do more, and in this respect, they were like most adults in the workshops I've run.

I observe this delight and excitement and realize how very much adults need the opportunity to create. This book isn't for just the chronological child; it's for the creative child who needs to be nurtured and cared for in all of us.

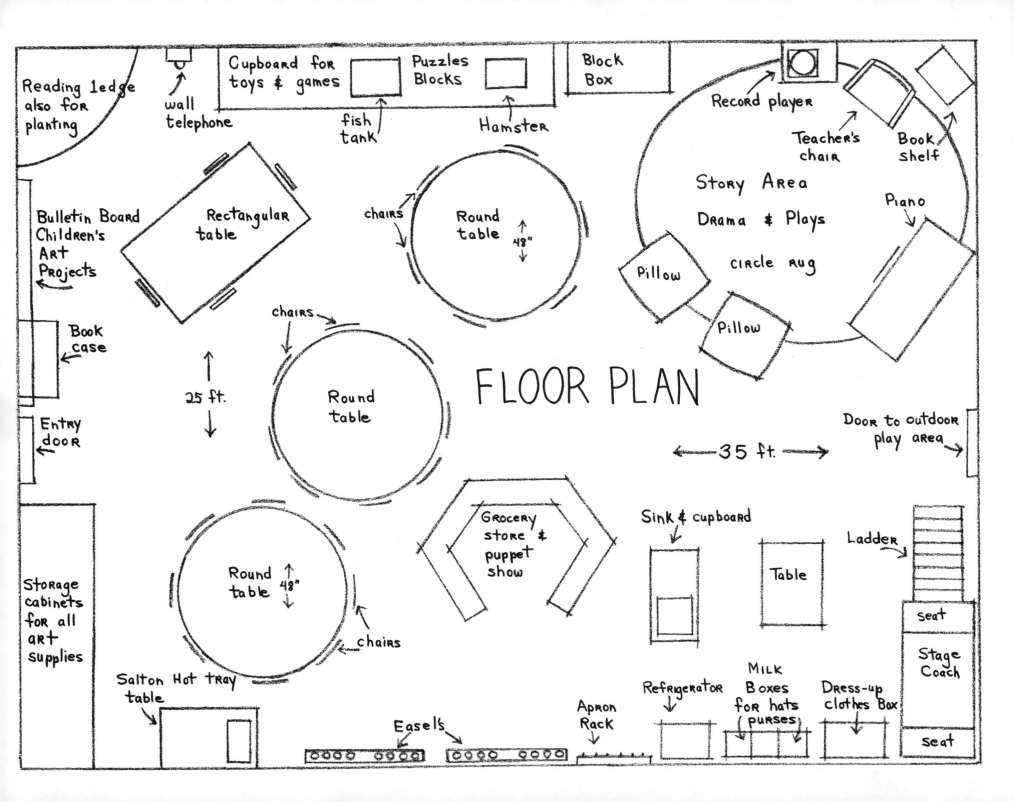

# getting the feel of it

The question parents and teachers at my workshops most frequently ask is, "How big is your school? How much room do you have?" They don't believe me when I describe the size of our facility. I'll share it with you. The building is forty or fifty years old. It has high, dark ceilings, high windows; I'd give anything for windows we could see out of. We have cement floors, an 8x10 bathroom, an 8x10 kitchen which has always doubled as our office, and one main room (see Floor Plan), with a covered patio and play area.

We have used every inch of space. For example, there is nothing more annoying in a small room than tripping over the legs of an easel. Attach your easels to the wall if you can. We designed one made of bright, easy-to-wash laminated plastic, permanently attached to the wall. Clamps hold the paper; a five-inch ledge with round

holes holds six-ounce plastic glasses with snap-on lids for paint. Four children can paint at once at this easel, which is wonderfully easy to clean, and the paint holders are not only spill-proof but good for paint mixing and for keeping paints from drying out.

Sometimes workability should take priority over space, however. If you are planning a facility or changing equipment, get round tables if at all possible. Children are much more sociable at a round table. It's easier to pass things, and there's the added advantage of no sharp corners. We have three forty-eight inch round tables with laminated plastic tops; we had the tops made for us, adding the legs ourselves.

Eight children can have a snack at a forty-eight inch round table. Four or five children can work with art; three can fingerpaint on its top. Our tables are bright colors—red, orange, yellow. The colors give us a built-in advantage in giving directions: it's easy to say, "Take these to the yellow table."

You, too, need to look hard at your facility and use all the available space. Change the tables around; put them together; experiment until the space works for you. Each year is different. If there seem to be problems, push, shove, move things until the program works.

All right. You have the easels, tables. Now what? I can only tell you what we do, how it works for us; you must work out an individual program that suits you.

Our school is a cooperative, with the parents participating one day a week. We have five parents and twenty-four children per class, one in the morning and another in the afternoon. I set up the art program. My job is to know what children need in order to develop to the optimum. Parents may and do suggest art projects, but it is my responsibility to educate them, if necessary. I'm always at school at least an

hour before class, setting up the art, getting the clay out, putting out a few puzzles and books. Once the room is ready, a parent in each area has no problems helping with names, and after the first month, the school runs like clockwork.

I wish that each of you could visit our school and observe the children creating. This morning, with Valentine's Day coming up soon, I cut large hearts for the easels to use with red, pink, and purple paint. I set up fingerpainting on the table, with more large paper hearts to remove the designs. On the extra art table, I put out plastic lids cut with a heart design for tracing.

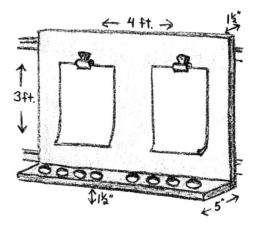

Our children arrive at 9:00. By 9:30, eighteen children had done fifty-three pieces of art. The easels have been up all year; fingerpainting is a regular activity for us; and the plastic lids are always available. But changing the shape of the paper and the paint color made these projects entirely new as far as the children were concerned.

If you could observe the joy of children creating their own art, you would never think "craft" again. Crafts have a value, of course. There comes a time when a child wants a very specific object to take home—a soap dish, a trivet. But such activities shouldn't be called "art" and shouldn't substitute for an art program. I make my own distinction between "art" and "craft" by asking how much participation by an adult is needed once I have presented materials. When the activity is truly art and genuinely creative, all I have to do is to put a name on the paper or perhaps stand by to add to the supplies.

When we think of art for children, we too often think of media and product first and only then the child. We need to be sensitive to the child *first*—sensitive to growth and development, aware of the child's needs. Then we can appropriately think about media. Children do not need to be coerced into doing art. If program materials are presented in the right way, the child will use them to grow and develop.

The young child grows from the head down and the midline out. If we are in tune to the child's growth, we know, for example, that a two-year-old will probably not paint or draw circles. Does this mean a different set of activities for each age? Certainly not. We need only to learn to present materials and let each child develop an individual creativity. The three-year-old will expand on the same art the two-year-old does. The four-year-old may spend twice as much time as the three-year-old spends or do twice as many pieces.

No activity in this book is intended for use by all children in a class on a given day. This might happen, but the day that it does will be a rare one. I do not "teach" or present art to a class of twenty-four children, but instead present a variety of art activities to twenty-four individual children, some of whom may do no art at all for two days and nothing *but* art for the next six days.

Realize that the preschool child has had little experience with art materials. In the beginning, the most important thing is an exposure to those materials in a very basic, simple way—one that will provide for the repetition that children need. In order to learn, children must not only be actively involved but also do things over and over. Learning to manipulate scissors, staplers, hole punches is a difficult process; it is only through manipulative repetition that learning occurs. Crayons—large, easily handled crayons—paper, and scissors should always be available, together with hole punches, staplers, tape of several varieties, small amounts of paint, and a variety of painting implements.

In order to develop plans that will keep children sufficiently interested to get necessary experience, we will always benefit by observing and taking our cues from them. For example, I noticed one day that a child had taken a pair of scissors to the clay table, something to be definitely discouraged when I first started teaching. I watched him cut clay into pieces for ten minutes, a long time in terms of preschool interest span. Now we keep two or three pairs of scissors in the clay.

Variety is the other key to holding the child's interest. It's up to you. Your own mental energy is the only limit. Vary the paint. Vary the color and shape of the paper. Vary the size of the paper. Vary the brushes and painting implements.

Finally, teachers, like important equipment, need to be visually apparent to children. At our school, I am the one person there every day. In order for a program to work, one person needs to be a constant—always there, ready with a hug or pat, always available to rock the child in tears. The most gifted teacher in the world can develop a program, but unless that teacher has the energy and concern to make that program work for each child, it won't work at all.

During the two and one-half hours the children are there, I don't spend any time on the telephone or doing paper work. A sign by the telephone says, "Unless it is an emergency, my time must be devoted to the children. Take a message. I'll call back after noon." It's too easy to get involved with telephoning or paper work; if you do, the children and your program will suffer.

Staying with the children is not the only groundrule I have for myself. Here are some other important things to remember in working with children and children's art.

## rule one: don't interfere

Children need to please only themselves. Does this mean the child can throw the paint? Spill the glue? Of course not. I'm referring to basic use of art materials. Once you've presented the materials, forget how *you* intended them to be used. Sometimes it's difficult. You may have one end product in mind, but the child may have another idea. If that's the case, hands off! it's easier to observe this principle in art activity than in crafts because there is no right or wrong in art, of course, just creating.

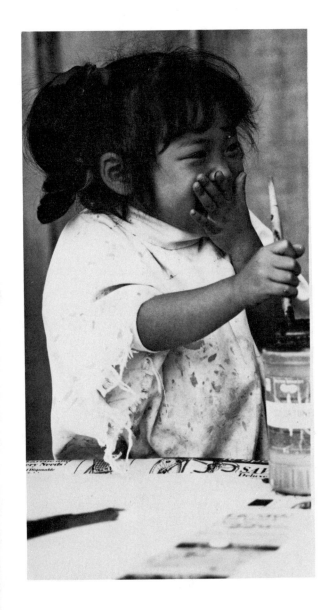

## rule two: try one yourself

Children pay attention to and get involved with anything that is interesting. Too often, parents and teachers feel that a problem of inattention lies with the child; more often the problem lies with inadequate adult planning. It is often very difficult to be certain about paint consistency, appropriate paper size, or other potential practical problems unless you take the time to do a practice version of the project yourself. Build this trial version into your setup time. You'll be much more at ease with the first child's attempt, and no child will have to stand around losing interest while you make last-minute adjustments.

## rule three: put the child first

Each day is special to a child. Be sensitive to individual needs; give each child optimum room for growth by doing two things. First, listen carefully to each child and try to provide what the child asks for. I try *never* to say, "We're not doing that today." If humanly possible, when a child asks for materials that are alternatives to what I've set out, I provide those materials. Second, avoid potential problems by being careful in the way you present materials; for example, when giving the child paint, put just a small amount out, so you don't have to be constantly concerned with spills or how much the child is using.

## rule four: avoid models

By models, I mean those things you have made for the child to copy. *Never* make a model to show to a child. In the first place, it's insulting. It's like saying, "You don't know what a turkey looks like, so I'll show you." I've heard teachers say, "Well, I always tell them they can make theirs any way they want, even if I make a model." This isn't a solution. I know how inadequate I feel trying to copy any product made by someone much more skilled than I.

When I do adult workshops, I bring drawings done by an artist, put them up, and ask the participants to copy them, so they can see how art activity feels when one has been presented with a model. Of course, it feels terrible. Would you be happy and excited about drawing in the face of that kind of threat to *your* end product? As teachers, we must be sensitive to feelings. Children do know what turkeys, apples, and trees look like; they're able to see. Let them. And let them create without the intimidation of a model.

---

## rule five: respect a name

At one time, the children in our school were painting over their names, which I'd been placing in the upper left-hand corner. I finally realized that I hadn't been thinking about the child at all in stressing an exact placement. Now we ask where the child would like the name, and no child paints or draws over a name any more.

Ask, "Where would you like your name?" When the child shows you, spell it out as you print it, or, as my daughter did in visiting the school one day, ask, "Do you want to write your name, or should I do it?" (Please note that she didn't ask, "Can you write?") About half the children she worked with wanted to write their own names.

Often a child will write a name backwards, You may see "Ttam" for "Matt." Sometimes you will see scattered letters. If the name can be deciphered at all, leave it alone. It's insulting to the child to rush over and write a name. Again, think how you'd feel if an instructor scratched your name out and rewrote it. The preschool child will learn the order of the letters soon enough.

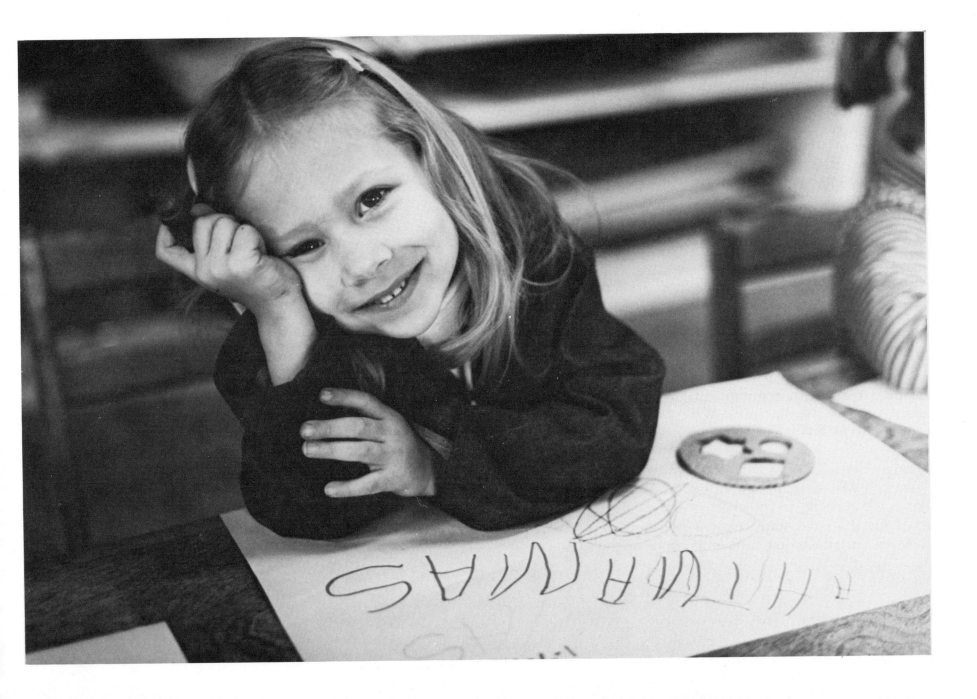

## rule six: don't delay

Art for young children should be "instant." One child may do twenty versions of the art you've presented; another child may do one. In planning your art program, however, remember that a young child wants to see *immediate* results.

## rule seven: spread the word

If you are a teacher, orient your parents to a child-centered approach. Help them to realize that the young child cannot cut out circles, color in the lines, or draw a person complete. Help your parents know how the child develops. If you are a parent, help other parents understand developmental approaches. Make it clear to your teachers that you don't want "art" produced for your benefit, but rather a program that is aimed at developing your child's creativity.

## rule eight: no leaping, please!

Often in the instructions to the projects that follow, I mention "gentle guidance." Too often, adults leap upon a child when something starts to spill, tip over, fall from the table, or simply begins to go in a direction different from the one the adult expected. I'm sure children have sometimes been frightened to the point of not trying again. Gently, *gently*, guide and suggest.

## rule nine: don't feel guilty

One of the feelings you may have when you start applying this book is guilt— guilt because you've done crafts to the exclusion of art, guilt because you haven't nurtured your children's creativity enough. I've been through all that myself—as a

teacher and as a parent. I shudder when I think of the "art" I did ten years ago. I feel sad when I think of my own five children, whose creativity I did almost nothing to foster. But feeling guilty is a waste of time. Don't do it. Start now, with your own children, grandchildren, with adults you know, with the parents of other children. Start with yourself.

### rule ten: discourage "good" clothes

We have aprons, coverups, paint shirts available at our school, but only if the children want to wear them. No matter what tactful name you call them, some children will object. Solve this problem in advance. At the beginning of the year, I tell my parents, "Go to a thrift shop; buy your child two outfits for school. Then you'll not be upset when the clothes come home with paint all over them." The preschooler needs to paint, to move, to grow, to develop. To heck with aprons. I'd never coerce a child into wearing one!

# paper

Preschool children are delighted to have paper available to paint, color, tear, or paste. They do not care if the source of the paper is the classified section, computer paper printouts, or leftovers from print shops. At our school, we buy very little paper in order to be able to spend our paper budget on really special materials. We buy, for instance, three or four rolls a year of colored duo-coat paper, which is quite expensive, but which we can afford because we do a lot of scavenging for our everyday paper. Sources of free, or almost free paper will vary from community to community, but the following are good, with some suggested sources and uses.

*Newsprint:* Very inexpensive. Go to local newspaper office to buy. Use on easels, for tearing, footpainting, musical drawings, screen painting.

*Classified Sections:* All the uses for newsprint, above.

*Wallpaper:* Do local dealers throw books out seasonally? Use for easels, Easter hats, negative space painting, collages.

*Print Shops:* Left over scraps are marvelous for many art activities. Use scraps at the cut and color table, for marble painting, utensil painting.

*Cardboard:* Use your imagination to acquire. Once I found a box of sixty shirt cardboards on the sidewalk in front of a men's store. Some stores throw out stocking boxes; they are wonderful weight for collages.

There are many papers, in addition to the duo-coat I mentioned above, that you will want to include in your programs and that you will have to buy. Check the catalogs of your local school supplier regularly. There are always new products being offered. The following papers are worth considering for purchase.

*Butcher Paper:* A large roll of heavy-duty butcher paper can be cut to any size and is thus much more economical than commercial fingerpainting paper, which comes in set sizes. Children are delighted with it.

*Tissue Paper:* Get a variety of colors to be used for collages, brayer painting.

*Construction Paper:* Nice to have, but we actually use very little in our school; we're able to substitute print shop scraps for the same uses.

*White Drawing Paper:* Many kinds are available—typing paper, onion skin, which is especially nice for melted crayon art.

*Coffee Filters:* The nonfluted variety are best for use in foldovers and dip and dye.

*Paper Plates:* We use them sometimes simply for variety.

## art table paper

*What You'll Need:* Paper—any fairly heavy duty quality—cut into twelve-inch circles; paper scraps, cut into smaller than twelve-inch circles; glue or paste; felt pens or crayons; brushes. Optional: "things" to paint with; watercolors or tempera paints; scissors; tape.

*How To Proceed:* Present the small circles to be pasted or glued to the larger ones. The children may want to draw or trace around the shape they've glued or pasted.

*Variations:* After you've presented the shapes with crayons and felt pens, try watercolors, tempera paints in one color and then several. In addition to brushes for the paints, try other utensils. Have the children tear or cut their own shapes to put onto the larger circles. Put out the transparent tape dispenser one day instead of glue or paste. After circles, squares, triangles, be sure to present free-form shapes. Pennant shaped paper, presented with the side end to the child's left and the point to his right may encourage left to right use of the paper. This will be a side benefit if it happens. If it doesn't or if the child wants the point to the left, don't put the writing value above the art value by insisting.

*Traps:* Be sure to have enough paper cut. It really doesn't take much time and saves wear and tear on the adults immediately involved: it's difficult for preschool children to wait. Some schools have parents who are obliged to do art projects for college coursework or who simply want to help. Have them cut paper. It's so easy, yet so vital to your program.

## cut and color table

One of our primary activities with paper takes place at a frequently set up art table which I mentioned in the introduction. At our school at least one child a day walks in saying, "I want to color and cut." One of the primary values of the cut and color table is the variety it provides and the freedom it thus gives for the child who doesn't want to have anything to do with the standard shapes we present at holiday time, for example. Early in the year, the returning child, who's been working for two years with the shapes we're introducing may be more interested in working on abstractions or more complicated projects.

*What You'll Need:* A variety of items from the following list: hole punches, scissors (in a styrofoam egg-carton holder), a variety of papers cut into various shapes (construction paper scraps, newspaper roll ends, adding maching tape, computer paper), staplers, transparent tape in a sturdy dispenser, masking tape, mending tape, brass brads, paper clips, paste or white glue, crayons, felt pens, self-sticking labels (''sticky dots''), damp rags.

*How To Proceed:* Place the items on the table. The children will simply cut, staple, punch, brad, clip, glue, paste, and tape to their heart's delight.

*Comments:* It's a wonderful way to develop eye-hand and muscle coordination, but this is a side benefit.

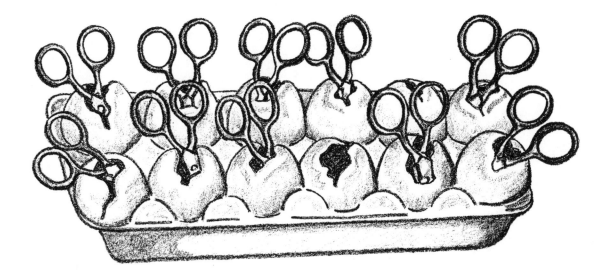

*Variations:* Add pieces of yarn to weave into punched holes. Tape the ends of the yarn or dip them into paraffin to make them easy to thread.

*Traps:* Be sure to use sturdy staplers and sturdy tape dispensers. They cost a little more in the beginning, but we've had our two staplers for twelve years. Avoid the handheld, disposable tape dispensers: even the teacher (at least this one) gets stuck using the hand-held variety.

## easel paper

By now, I hope you're getting the feeling of how you can take a simple shape and present it in many different ways, letting the child create and develop. Remember that in creative art there is no right or wrong. The art belongs to the child. For a discussion of paints and colors at the easel, see Chapter 3, easel painting.

*What You'll Need:* Paper—newsprint, butcher paper, cut or torn to size. Preparation time depends on how fast you cut. I cut five or six pieces at a time while talking to friends or watching television.

*How To Proceed:* Cut the paper into the desired shape and clip it onto the easels. Early in the year, circles are best. They have no difficult corners—ever notice how young children don't paint in the corners?

*Comments:* You'll see children painting around and around—just the kind of movement you want—wrist and elbow movement. Some, of course, will paint vertical lines, but the circular shape will emerge in time. Don't be concerned about drips. Children need to find out for themselves that paints run, drip, and children need to be encouraged to clean up, too.

*Variations:* Use circles as long as you wish, and introduce them again during the year. Then change paper to rectangles. In December, try large triangles, then squares, ovals. Free-form shapes are always good to alternate with the specific forms you're working with; simply tear off a corner. Present the paper without comment. We really don't have to beat children over the head by repeating, "It's a circle; it's a circle." They know.

## floor paper

Large circles, squares, triangles can be put onto the floor, where everyone can paint at the same time. Use crayons or felt pens on one piece of paper. This activity will make children aware of their own space, and they will socialize while developing their own projects. They will see that every work of art is different, yet the same in some ways. For variations, see art table paper.

## negative space paper

Of all the art we do, this is the one I most enjoy watching. The children really become artists. Some of the younger children—three and under—will ignore the hole you have cut and end up with paint on the easel or table. I don't comment on this. I ask if they're through and where they want their names. The younger children

will discover for themselves through experience. Older children really use the hole in the paper to create a picture: sometimes they use it as a body, putting legs on it; sometimes they use the hole as the center for a flower. It delights me when they paint around the shape and discover new shapes. Whenever we do this art, we can be sure each child will take home three or four pieces.

*What You'll Need:*  Any paper, with a hole that you have cut in it. I want to stress here the value of abstract shapes. The hole may be cut to any size and shape; you may cut two holes or more, if you like, but I feel it's better to start with one early in the year. You will also need crayons or felt pens, watercolors, or paint—first in one color, then in two.

*How To Proceed:*  Present the paper without comment at the easel or at the art table. Have the children draw or paint as they like.

*Comments:*  Think about it. Each time the child paints colors on this paper, the space can be something else. And the art is always the child's. The teacher or parent does so little, and the child develops so much. The art is instant, creative, developmental, joyful!

___

## outside paper

Often we staple or tape paper to the outside of the school building. Many children who won't take time to step inside will paint outside. A good container for paint is an old round dishpan filled with sand. We wiggle our plastic paint containers down into it for stability.

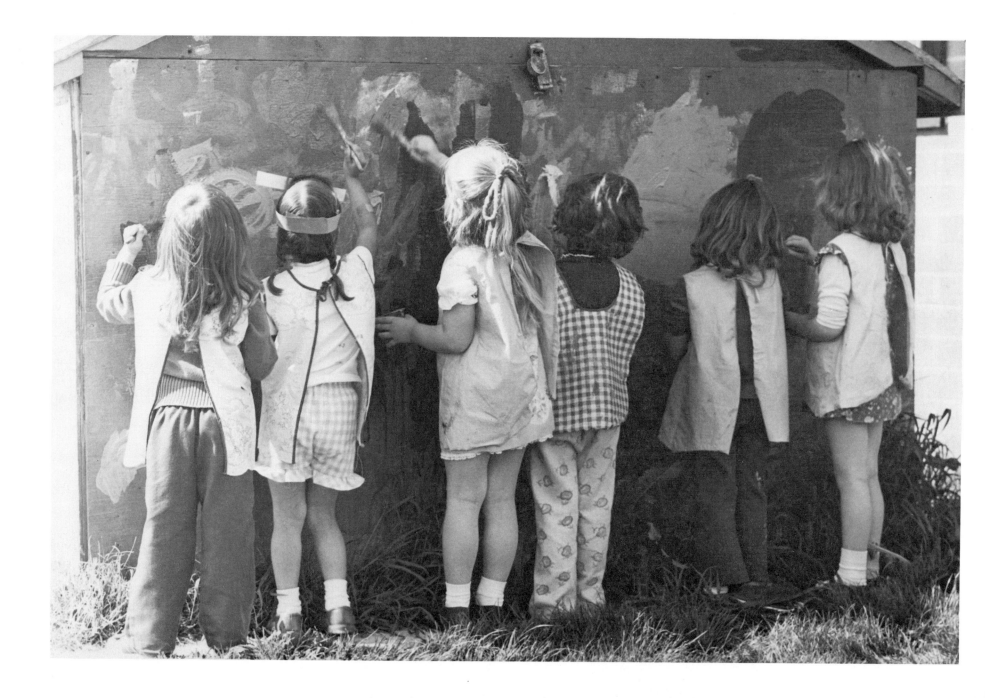

## sticky dots

At most stationery, art, or school supply stores, you will be able to find "sticky dots." These are small, self-sticking circles, squares, and rectangles that are used to label and price objects. They come in many bright colors in packages of a thousand. If I could, I'd purchase ten thousand of each color. The children love them; they "stick" a design on construction or scrap paper. We use them for collages as well. Sometimes I present sticky dots with crayons and felt pens, and the children connect them or draw around them. Our children have made magnificent free-form designs entirely from "sticky dots," even pictures of houses and trees.

*Traps:* There aren't any.

## tearing paper

This can be done as a special activity with a single energetic, active child, with three or four children, or with all the children during circle time.

*What You'll Need:* Lots of newspaper.

*How To Proceed:* Place the single sheets of newspaper on the floor. Have the children tear the paper.

*Comments:* What's in it for the child? Muscle development, creation of shapes while tearing, just the sheer joy and use of energy. On a rainy day, when children need to use their tremendous energy, tear paper!

## tissue paper

Tissue paper comes in such brilliant colors and is so fragile and light that children need to learn to work and create with it as well as with heavier papers.

*What You'll Need:* Tissue paper and a piece of construction paper or cardboard, a brush, and a small container of liquid starch for each child.

*How To Proceed:* Give the children the tissue; they may want to cut or tear it into small pieces or geometric or freeform shapes. Present the cardboard, which the children can brush with starch and cover with tissue. The tissue can also be placed directly onto the cardboard and the starch brushed on top.

*Comments:* The child, again, creates here, as well as discovering new actions by overlapping two colors of tissue. The child learns to handle delicate, thin paper, finding that a little puff of air moves that paper around. The child learns about colors, shapes, and sizes in addition to movement and brushing.

*Variations:* The tissue can be twisted, wadded, and then placed on the paper. Thinned white glue can be used instead of starch. Simply thin with water until it's easy to brush.

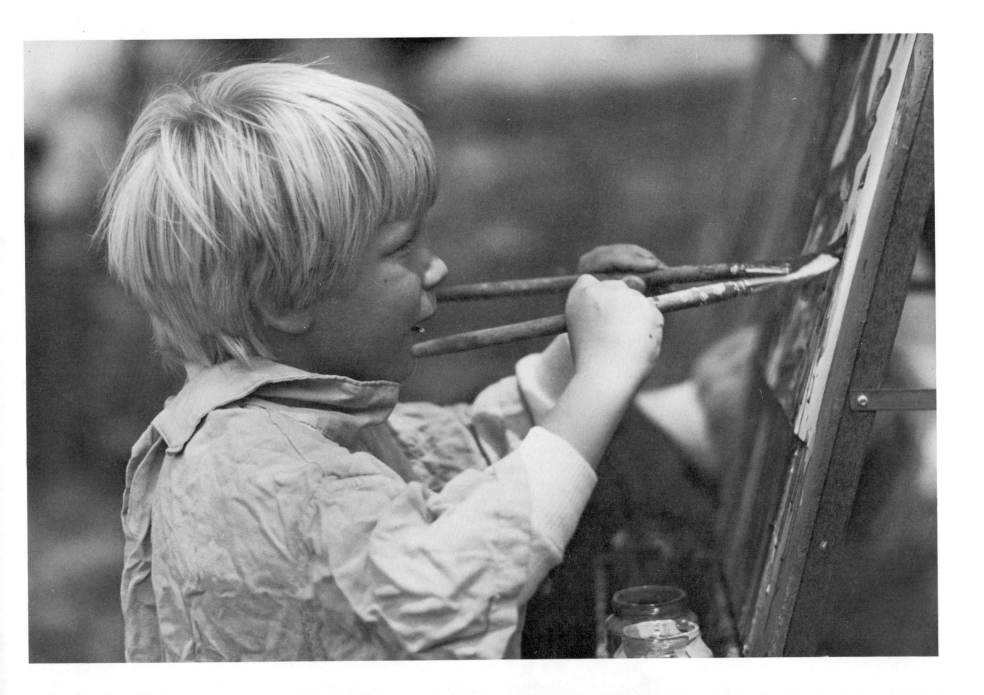

# paint

All schools buy their paint from different sources. We buy ours from a wholesale school supplier. I never buy premixed tempera because it's much too expensive; instead, we always order second-grade dry (powdered) tempera. It's less per pound can and is a sufficiently good grade of powdered paint. Its colors are bright, and the only difference I've discovered between second and top-grade paint in our use of it seems to be that the lesser grade takes a little longer to mix.

Many art "how-to" books place great emphasis on primary colors. Certainly I start the year with red, yellow, and blue, but I feel strongly that children must be exposed to all colors (see Chapter 10, planning). After all, children see all colors every day. Black paint, for example, is often ignored in preschools, but children love the contrast it provides.

Children should be allowed to mix their own paint, but the presentation can be disastrous without controls; for details, see the project on children's paint mixing. When I mix paint, this is how I do it. Incidentally, I'm not big on paint extenders. They're time consuming, and I've not found them to work all that well. I fill an

eight-ounce plastic glass, the kind with a snap-on lid, about two-thirds full of dry tempera. I add water to the top and close tightly, then shake vigorously until the paint is smooth and add a few squirts of liquid detergent to aid cleanup. I should have enough paint here for two containers for easel painting or to put in small plastic containers for the art table.

## blindfold painting

I feel children need to develop an awareness of the world around them, and a sensitivity to people with handicaps is part of that awareness. Children will understand better if they actively experience.

In our school, we talk about what it would be like if we couldn't see. We talk about how we'd find the bathroom, how we'd find our plates at breakfast. We also try painting blindfolded. I don't pressure children who don't want to do it.

*What You'll Need:* A bandanna or large handkerchief for a blindfold and an easel setup for painting because it's probably the most familiar to the children.

*How To Proceed:* Blindfold the child. Suggest gently that the child feel the paper, the easel before starting to paint. Don't rush the child. Give adequate time to find the brushes, and try not to volunteer too much help.

*Comments:* The children in our school are just delighted with the painting they can do without seeing. In a quiet way, we talk about the fact that if they really couldn't see, they wouldn't be able to enjoy looking at the painting they did blindfolded.

## children's paint mixing

*What You'll Need:* Masking tape or a 10 to 12 inch square piece of wood or plastic; dry tempera; water in a small plastic measuring cup; measuring spoon; two small empty margarine containers; a sturdy spoon for stirring; appropriate paper.

*How To Proceed:* Mask a small area, about ten inches square, on top of the art table, or provide a ten or twelve inch square piece of wood for each child. The masked area or wood piece is to provide control for the child. Remember that the child really cannot concentrate on more than one thing at a time. Here, the most important thing is the paint mixing experience. Put about four ounces of water into the measuring cup and about three to four tablespoons of dry tempera into one of the margarine tubs. Allow the child to mix the paint. Do not comment on the thickness, thinness, lumpiness of the paint. Let the child discover all these things. If asked, you might gently suggest more paint, more water, more stirring. Offer paper so that the child can use the paint just produced.

*Comments:* Mixing paint offers several wonderful experiences: in addition to wonderful stirring movement and eye-hand coordination, it offers the discovery of how paint becomes liquid—a delightful realization for a child. It seems so obvious to us, but we forget that children learn through experience. They are delighted to discover that yellow and red make orange, that red and blue produce purple.

*Variations:* This art project can start at the beginning of your school year and continue forever. Think of the possibilities in presenting first the primary colors and then combinations, with different papers to paint on.

*Traps:* We offer this activity at an "extra" table. Not all of the children do this activity at once; three or four children at a time are really more than enough for one person to help adequately. There will be spills, and the young child may need help. Encourage the children to clean up when they're through, of course. Control the amount of paint and water so that when they're through they have enough to paint a picture, but you don't have a quart of red paint left over. If the child is interested only in mixing and doesn't want to paint with the mixture, save it in a container to use at the easel.

## drip painting

*What You'll Need:* Paper cut into desired shapes or rectangular easel paper; small containers of paint—two or three per child; brushes.

*How To Proceed:* Place the paper on the floor and have the containers of paint ready. Have the child dip the brush into the paint and let the paint drip onto the paper. Start with one color; add another.

*Comments:* Children develop control as they try to place a drop here and a drip there, but don't force the issue: if a child wants to paint with the brush or brush the drips, great!!

*Variations:* Vary the shapes and types of paper as well as colors. Dripping white paint on black paper is as interesting as dripping black on white.

*Traps:* Children must know the rules. Paint may not be thrown.

## easel painting

Easels seem to be used in every school, but I feel the easel is often not used to its optimum, perhaps because it is such a standard item and always available.

If at all possible, have your easel made for you. We have had easels made for our school which are attached to the wall, where they cannot be kicked over or tripped over. Four children can paint at once. This allows for much interaction and socializing

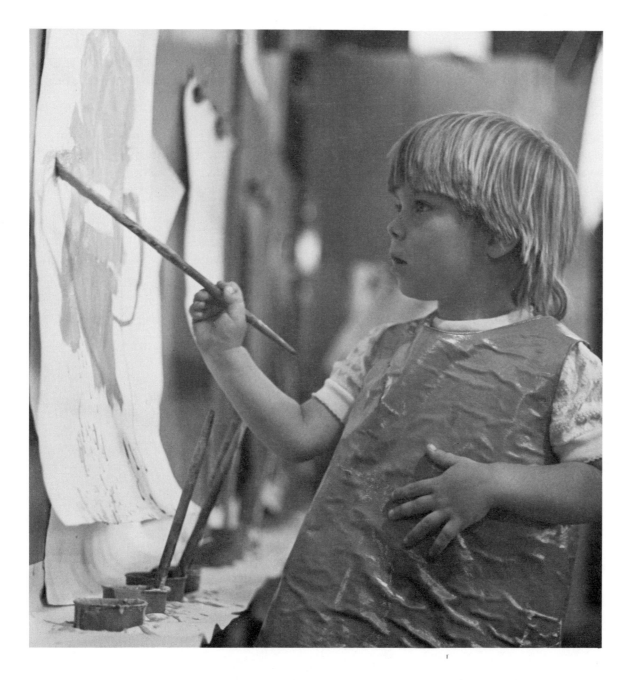

while painting; the children can comment on one another's work. Note that the easel is made so the paint cups cannot tip over and that the laminated plastic surface makes cleanup a simple thing.

Think about varying the easel experience. Provide different kinds of paper. In mixing paints for the easel, don't allow primary colors to dominate. Use white tempera to make pastels; remember that children see all colors in the world around them.

## fingerpainting

Many children hesitate to fingerpaint. Some paint with only one hand, others with only two fingers. Try to understand why the child is hesitant: think, for a moment, how mothers emphasize "clean" hands. The child is kept "clean" from the moment of birth.

Suggest, gently, that the child feel the paint. Is it cold? Is it smooth? If only a few smears are accomplished the first time, there's nothing terrible about that. One little girl in our school this year fingerpainted for ten seconds, washed her hands for two minutes, fingerpainted for ten seconds, washed again for two minutes and alternated in this pattern for fifteen minutes! My feeling is that they were, after all, *her* hands.

*What You'll Need:*  Masking tape; large (18x24 inch) sheets of heavy duty paper; fingerpainting "goop" or liquid starch (see recipe at the end of this section); powdered tempera; measuring spoon.

*How To Proceed:*  On a plastic table top, mask off an area about 18x24 inches in front of each child; this will make it easier to pick up an individual "print" of each child's effort. Pour two or three tablespoons liquid starch or fingerpainting "goop"

into the center of each area. Have the children sprinkle a heaping teaspoon of powdered tempera into the ''goop'' and mix it with their hands. When they have finished painting, press a piece of paper on top of each painting and save a print.

*Variations:* Have the children fingerpaint to music, moving about the table in musical-chair fashion—or staying in place. Later in the year, provide butcher or fingerpainting paper and a good thick fingerpainting recipe (see below) and let the child experience fingerpainting on paper. Start with one color and add another to give access, finally, to a third. Fingerpainting can be offered as often as you can stand the mess. Try adding different ingredients to the ''goop'' to create texture. Use your imagination: sand will produce a gritty feeling, glycerine will produce a smooth, slick feeling. Try anything once. Toothpaste, catsup, mustard are other possibilities. At least once a year, the child should fingerpaint with chocolate or pistachio pudding.

*Fingerpainting ''Goop'':* You will need a splash of cold water, one cup powdered laundry starch, five cups boiling water, and one-half cup soap flakes. Mix the starch with enough cold water to make a smooth paste. Add the boiling water and cook the mixture until it is glossy. Stir in the dry soap flakes while the mixture is warm. Cool and pour into jars. This mixture, which is thicker than liquid starch, will keep a week or longer if covered with a tight lid.

## foldovers

I call these ''foldovers,'' but in some schools, this art is referred to as ''butterfly blots.'' I think the use of the term ''foldovers'' avoids putting adult ideas about the result into the child's mind in advance of the experience.

*What You'll Need:* Any heavy duty paper cut into whatever shape you're working with at the time; small plastic containers of tempera and a spoon for each child.

*How To Proceed:* Fold the paper in half and crease gently. Open the paper and have the child drip one or two spoonsful of paint at random on half the paper. (Don't be upset if paint drips on both halves.) Then have the child fold the paper over and rub, spreading the paint. Open to dry.

*Variations:* They're endless. Different shapes of paper, different combinations of paint can be done to great effect. Variations can be done with all the holiday shapes as well—pumpkins, trees, hearts, eggs.

## footpainting

Frankly, how often you'll be willing to do footpainting depends on how much mess you can stand. Encourage the children to do the cleanup themselves. We do this art two or three times a school year.

*What You'll Need:* Large sheets of substantial paper: newspapers will do; towels; a bucket of soapy water; a large, shallow pan (13x20 cake pans are perfect) with a small amount of paint in the bottom; a child-size chair; at least one adult to guide children if you choose the walking method.

*How To Proceed:* Have the child remove shoes and stockings and sit in a low chair. Place the paint pan on the floor in front of the child, and spread paper in front of or around the chair. There are now several ways to proceed. Once the child has feet out of the paint and onto the paper, you may simply have the child walk on the paper to the other end, where you've provided a bucket of warm, sudsy water for cleanup. You might suggest that the child try painting with toes only. As long as an extra adult is present (see traps), consider whether the child might want to dance or to move randomly on the paper. Sometimes I ask how the paint feels—warm, cold? Don't pressure the child into discussing it. Just ask, gently. Sometimes children love to talk about footpainting, and sometimes they want only to experience it.

*Variations:* Use a very long piece of paper instead of an individual paper for each child. By moving the chair down to a new place each time, have all the children who want to do so walk on the paper. Then hang the paper on the wall. It's fun to look at.

*Traps:* The walking method can be slippery; you will need at least one adult on hand to guide children if you use this technique. Another adult might be helpful with the washing up, but we find the children can usually manage quite well.

## glitter painting

*What You'll Need:* Paper cut into 9x12 pieces for painting on the art table; salt in a dish or in shakers (the small picnic variety works well); several small containers of paint; brushes or other painting implements.

*How To Proceed:* Have the children paint, and after they are finished, but before the painting is dry, give them the chance to sprinkle salt on the paint.

*Variations:* You can add salt to the paint before the child paints, but don't put it in so far in advance that it dissolves.

## marble painting

*What You'll Need:* A cardboard box about 12x15 inches and pieces of heavier-weight paper to fit the bottom; small containers of paint; a sturdy metal or plastic spoon; two marbles.

*How To Proceed:* Drop two marbles into the container with the paint. Have the child scoop the marbles out with the spoon and drop them into the box. Then tip the box back and forth so the marbles will roll around, making a design. The marbles can be dipped again and again until the design satisfies the child.

*Comments:* Marble painting is useful for movement and for eye-hand coordination as the child is watching all the time, getting the marble to "paint" as it rolls around the box.

*Variations:* Use different shapes of paper and one color of paint initially, then two colors. The children can then see that where two colors cross they make a third. Black paper with white paint is interesting. Slick paper will yield quite a different design from absorbent paper. By varying paper shapes and using appropriate colors, you can make marble painting good for all holidays.

*Traps:* Instruct the child carefully how to drain some of the paint by pressing the spoon against the side of the container. Otherwise a big puddle of paint will result.

## shaving cream painting

*What You'll Need:* Three to four cans of shaving cream; a little water in a plastic cup; a laminated plastic table top.

*How To Proceed:* Squirt the cream onto the table top and allow children to finger-paint. Sprinkle a little water if the shaving cream gets dry or stiff.

*Comments:* I do this so often that we buy shaving cream by the case when it's on sale.

*Variations:* Sometimes I add a dab of liquid tempera. Place the record player near the table for background music.

## spatter painting

The setup for this art is the same as for drip painting, only it is done outside, and children are allowed to spatter the paint gently. Adults are needed to keep other children out of the way.

*Variations:* Again, vary colors, shapes and kinds of paper. The classified section is good for this project.

*Comments:* The results can be quite lovely. One mother found the colors of her daughter's spatter painting just right for the family room. She put it into a chrome frame, and the painting now hangs over their sofa.

## sponge painting

*What You'll Need:* Two or three pie pans with liquid tempera in the bottom; sponges, cut into easily handled pieces; paper, large enough to hold lots of prints.

*How To Proceed:* Set out paper, pie pans with paint, and sponges. Have the child dip the sponge into the paint and then press the sponge onto the paper. Suggest to the child that the sponge doesn't have to go back into the paint each time, but can make many prints after a single dipping.

*Variations:* Sponges can be cut into any imaginable shape with a sharp scissors. Think of the possibilities: circles, squares, triangles, turkeys, trees, pumpkins, free forms of every shape and size. Cookie cutters are good for designs to trace. I usually set out the sponge remnants with the shapes I've cut and let the children use what they wish. As with any art, the colors of the paint can be changed, extended. Be sure that you have enough sponges cut for various colors. As is the case with "thing" and utensil painting, sponge painting is also a printing activity.

*Traps:* Most adults think it would be lovely if the child dipped the sponge into the paint and made perfect designs on the paper. After all, they've just spent hours carefully cutting special shapes. But many children dip and smear and rub the paper with the sponge. Remember that the art belongs to the child. If you're tempted to ask why you should bother cutting the sponges into shapes at all, remember that the child will be able to see and feel the shape you cut. One day, the child may dip and make a "perfect" print. Let the child have the experience of discovery.

## straw painting

*What You'll Need:* Slick-surfaced paper, about 9x12 inches; short plastic straws (or long straws cut in half); liquid tempera, not too thick, in margarine tubs.

*How To Proceed:* Place the paint container next to the paper. Have the child dip the straw into the paint, move the straw over the paper, and drop the paint onto the paper. Holding the straw as close to the paint as possible, the child can blow paint in any direction until the puddle or drop is gone. The result is a spidery design.

*Variations:* Use different papers; experiment with different colors of paint.

*Traps:* It is especially important here to try one painting yourself before the children arrive. Be sure the paint is thin enough to blow easily and thick enough to resist soaking into the paper too soon.

## string painting

*What You'll Need:* Any heavier-duty paper, cut into desired shape; liquid tempera; a pie pan; paper toweling; 18 to 24 inch lengths of yarn or string.

*How To Proceed:* In a dish the size of a pie pan, make a thick pad of paper toweling. Pour the paint to soak the pad well. Press the yarn or string into the paint pad, making sure it's well soaked. Have the child place the wet string on one half of the paper, leaving a trail of about one inch hanging out. Fold the paper over the string, and then have the child pull the string out. When the string is pulled, the paint leaves fascinating designs. Often the child will be able to see recognizable shapes—flowers, ducks, birds. Perhaps more important here is the exposure to freeform design.

*Variations:* One variation proceeds as above through folding the paper over the string. After the paper has been folded over, have the child press on top of the paper. Then open the paper and lift the string off. A second variation requires two paint pads of different colors and two strings. Use both, and where the strings cross, the child will be able to see a third color.

## "thing" painting

*What You'll Need:* Paper of any size for the art table or any small paper scraps; small containers of paint in one, two, or three colors; one or two implements for each child from the following—cotton swabs, eyedroppers, cotton balls, hair pins, bobby pins, barrettes, empty thread spools, corks, popsicle sticks, tongue depressors, eyeliner sponges, cosmetic sponges, powder puffs, toothbrushes, cardboard tubing; one styrofoam meat tray (6x8 or 5x7) for each child.

*How To Proceed:* In one of the trays, place one or two "things" to paint with. Pour just a little paint on the other end of the tray. Present the tray and let the child paint.

*Comments:* Of course, many of the "things" suggested here can also be used to print with.

*Variations:* Present different colors of paint, paper shapes, "things" to paint with.

## utensil painting

By utensils I mean sponges with handles, dishcleaners made from string or sponges, spiral egg beaters, gravy mixers, toilet brushes, feather dusters, or small paint rollers. Does all this sound very weird? I never stop looking for utensils for our children to paint with. Every time I pass the kitchenware or hardware section in the grocery, I

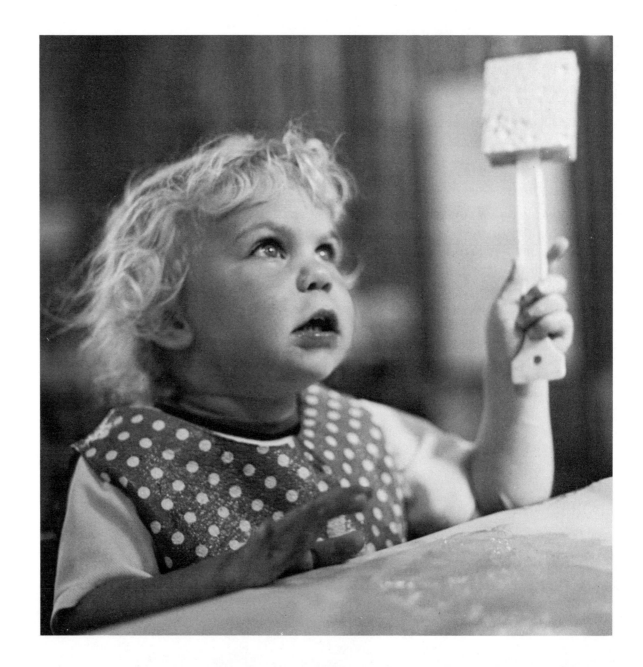

look. I haunt art and paint stores for new utensils. I've carried toilet brushes home on airplanes because I saw a new kind while away from home. I never see a new object without asking myself, "Can we dip it in paint and make a print?" Try anything once!!

*What You'll Need:*  Large pieces of paper—circles, squares, rectangles, or freeform shapes; cake or pie pans with small amounts of liquid tempera; utensils of choice.

*How To Proceed:*  The large paper is to provide maximum movement for the child. Have the child dip the utensils into the paint and then make a mark on the paper.

*Comments:*  Some side benefits are movement and muscular control.

*Variations:*  Sometimes we provide only one utensil, sometimes two. I would certainly begin with only one. We do this art at least two or three times a month with different colors of paint, different kinds and shapes of paper. It can be done on the floor, using still larger paper, or even outside.

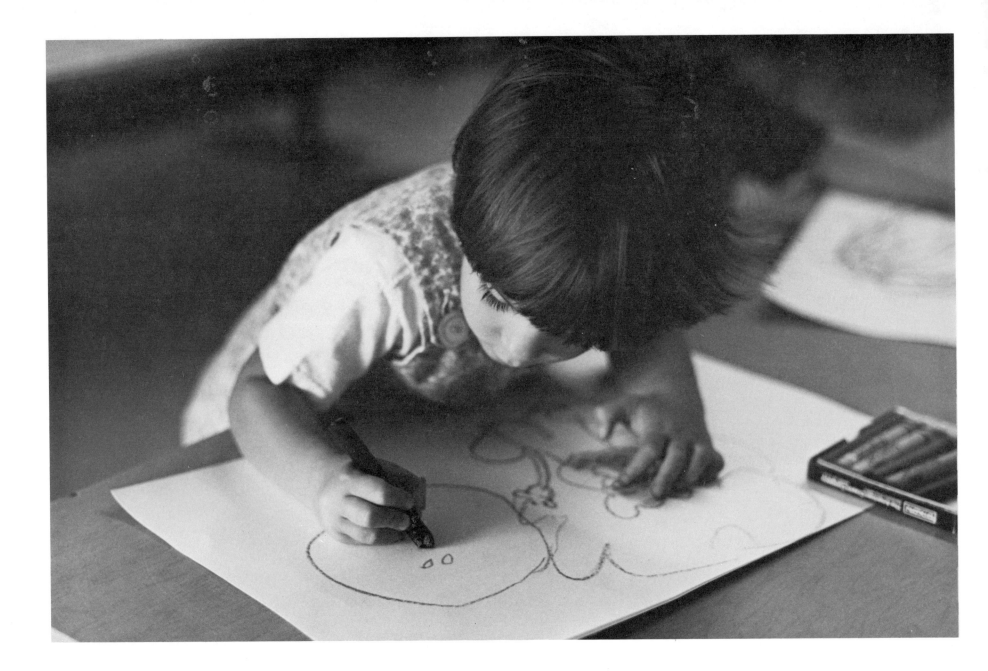

# crayons, felt pens, chalk

Everyone knows about crayons and coloring. Crayons need to be readily available. Try to establish a practice that children may ask at any time for crayons, or, even better, keep crayons and paper where children may get them to color with at any time.

We buy good crayons. In the beginning of the school year, we use the flat, pre-school crayons. I think it's nice, however, to let young children color occasionally with small crayons as well. I buy a large box of sixty-four because it contains a wonderful variety of color in addition to the metallic crayons—gold, silver, and bronze. The children love them and take good care of these special crayons.

The variations you can provide to basic coloring are endless. Provide a variety of papers. Suggest different places and positions for color activity: on the floor, lying down, standing up.

## cookie crayons

It's amazing how a crayon of a different size or shape can intrigue a child. We don't offer these crayons all the time, but we have them available. To many people, they may seem like too much work, but we love them. So do the children!

*What You'll Need:*  Non-stick muffin tins and peeled crayons or crayon stubs in a variety of colors.

*How To Proceed:*  Place the peeled crayons in the muffin tins. You will need at least six or seven regular crayons, as you'll want a fairly thick end product. Be sure to use a variety of colors. Place the muffin pan in a 250° oven until the crayons have melted. Don't move the muffin tins! When the crayons have melted, turn off the oven, and when the oven is completely cold, remove the muffin pan. Push on the bottom of each section, and the cookie crayons should pop right out.

*Traps:*  Be patient. I am prepared by experience to tell you that if you move the muffin tins, the melted crayons will mix and you'll have a dozen or two mud-colored crayons.

## rainbow crayons

*What You'll Need:*  Plastic containers, like film containers or pill bottles; an old pan; a dozen or so crayons, two or three in each color, for each rainbow crayon; some paper toweling.

*How To Proceed:* In an old pan, on low heat, melt two or three crayons of the same color. Crayons are not so flammable as paraffin, but take special care. When the crayons have melted, pour into your container. Clean the pan, while it's still warm, by wiping it clean with a paper towel. After the first layer has hardened just to a firm stage, melt more crayons and add another layer in a different color. Repeat until you've filled the entire container; a film can will usually take four colors. Let the crayon harden and tap the container to remove. When the children use the crayon on its side, they can make rainbows, stripes, and then, by changing the direction of the paper or crayon, plaids!!

*Traps:* Sometimes one layer will fall off. There's no remedy except developing a better sense of timing in adding one layer to another.

---

## crayon chips

*What You'll Need:* Crayon stubs; a heavy brown bag; a hammer or grater; two sheets of 9x12 inch waxed paper per project; an iron (old enough to be used only for this project).

*How To Proceed:* With a hammer, smash the crayons in a heavy brown bag or, if you like, grate them. Have the children sprinkle about two teaspoons of crayon chips on a piece of waxed paper. Then cover with another piece of waxed paper and iron—just for a few seconds—until the chips melt. It isn't necessary to measure the chips precisely; use just enough to make the pieces of paper stick together.

*Variations:* Provide small leaves, blades of grass, flower petals for the children to place on the chips before ironing.

*Traps:* Make one yourself first to get the feeling of this project. Be sure to take into account the hectic atmosphere that will surround this art. Ten children will be ready and you'll probably have only one iron, which will be hot! There's no magic solution. I don't do this art often, but it's beautiful and, if you're careful, fun. I would try it in February, March, or April—when everyone knows about rules.

## crayon rubbings

*What You'll Need:* Lightweight paper, like typing paper; peeled crayons for each child; things to rub over; pieces of embossed linoleum, grained wood, embossed greeting cards, pieces of screen.

*How To Proceed:* Have the children place the paper over the object and rub gently with a flat crayon until the picture appears.

*Variations:* Have the child take paper and crayon and look for things around the school that are suitable for "rubbings." One child rubbed the cement floor and took "sand" prints. Our jumping board has a good grain for rubbing. But, as the child will discover, some things are smooth and don't make good rubbings. All these discoveries are good for the child. In addition, consider seasonal rubbings, like leaves in the fall, Christmas cards in December.

*Traps:* When children are rubbing, it's difficult for them to hold the paper. Have a parent or teacher hold the paper until the child gets the hang of it. Be sure not to praise a copied picture, if one is involved, but rather the child's technique or simply the appearance of the picture.

## crayon tracings

Collect plastic lids from two-pound coffee cans or shortening cans. Using an abstract shape, a shape you're working with on the easels, or a holiday shape if appropriate, draw a simple design on the lid. With a sharp scissors, cut out the shape.

*What You'll Need:* Plastic lids, prepared as above; 9x12 paper; crayons.

*How To Proceed:* Provide materials on an art table. The children can trace the design, and by moving the lid a little, they can overlap their designs. Sometimes they'll want to color the design, so different colors of crayon should be available.

*Variations:* The variations are endless. Think of shapes—circles, squares, triangles, holiday shapes, freeform designs. You can offer more than one shape, but keep it simple in the beginning. Another variation is to offer felt pens rather than crayons.

## melted crayon art

At an extra table, in a corner behind the regular art table, we keep a warming tray, the kind used for keeping food warm on a buffet. We use it to produce melted crayon art. Beyond any doubt, this is the children's favorite art activity. Since the tray requires a warmup time, sometimes I must say, "The tray isn't hot yet; it'll be just a minute." We have one child who runs in every morning shouting, "Is it hot? Is it hot?"

*What You'll Need:*  A warming tray; unquilted aluminum foil; crayon stubs; a variety of paper; paper toweling; a pencil with an eraser.

*How To Proceed:*  Cover the tray with smooth, heavy-duty foil, or two sheets of regular foil. Overlap the edges and press so it doesn't slip off. When the tray is warm have the child draw on the foil with crayon stubs, which will melt on the foil. When the child is satisfied with the design, place a piece of paper on top of the foil over the drawing, press, using the eraser end of a pencil, and remove the design. Wipe off the excess wax with a paper towel before using the tray again.

*Comments:*  The designs can be incredibly lovely, especially with metallic crayons. Parents always ask about the tray's being too hot. We have always had a parent or teacher do the paper pressing in the past, but this year, after doing this art for seven or eight years, we're having the children do it all, with only a little guidance. When they press the paper, show them how to use the eraser to tap the paper down.

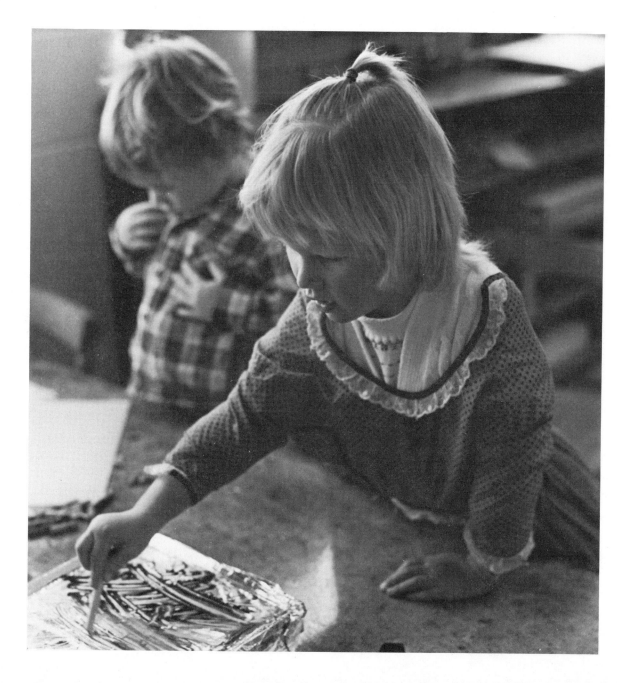

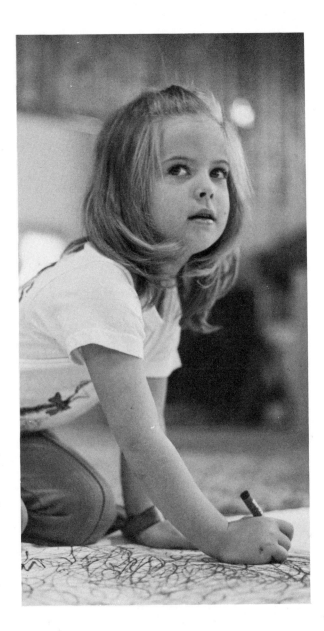

*Variations:* Put the paper directly onto the foil-covered hot tray and draw on the paper with the crayons. Vary papers: onionskin paper looks like stained glass, especially with the metallic crayons. Typing paper, printing shop scraps are fine. Don't forget to use the metallic crayons: they're simply beautiful.

*Traps:* The children love this art and will want to do twenty apiece. We handle this problem by letting each child make two or three prints and then giving another child a turn. We have a "Who's Next?" list next to the tray, and we put a child's name on the list for call when it's time. Be sure to call, or the child won't trust you again. I feel I should mention a potential trap. Often I'm asked if an electric frying pan wouldn't do. I wouldn't recommend this under any circumstances—first, because frying pans have high edges, and children would have to keep their wrists arched and out of the way, but second, and more important, the controls on an electric frying pan might easily be turned up when an adult wasn't looking and an accident result.

## musical drawings

*What You'll Need:* A large piece of paper for each child—newspapers, doubled or tripled, are fine or a very long piece of paper, at least six by eight feet; two or three large crayons for each child; some suitable recordings.

*How To Proceed:* Provide a large piece of paper for each child or, if you like, a single long piece so that many children can do this art together. Place the paper on the floor and give each child two or three large crayons. The paper must be large enough so that the children can move their whole arms.

Select a record. I prefer classical music and have had great luck with the Overture to *William Tell* or "The Thieving Magpie." I try to find a record with four or five musical selections. Tell the children to listen to the music and draw to it. Change music every thirty to forty seconds and have them change crayons when the music changes. They'll love the tempo. Suggest, "Big arms," to produce whole arm movement. When we finish a group of musical drawings, we hang them on the wall.

*Variations:* Another approach is to have the children color to three or four different tempos and then change music and ask them to color on someone else's paper. This activity makes them aware of how it feels to have anyone touch, paint, or color their art. Ask them how it makes them feel. Another variation is to have children switch hands when the music changes. Still another: have children color with both hands.

*Traps:* If you send these drawings home, attach a note or label the product as a musical drawing. They look like scribbling; unless you've educated your parents very thoroughly about such art, they may not realize its value unless you make the value explicit.

## felt pens

Children love felt pens. We use the waterbase ones with fairly wide tips. Most art you do with crayons can be done with felt pens. We offer them on an extra art table just like crayons. We had a problem with caps getting lost until we found a solution: mix a little plaster of Paris, enough to fill a plastic container the size of a large margarine tub, and place the felt pen caps upside down into the plaster. When the plaster hardens the caps will stay in, and the felt pens can be removed. If any caps come loose, simply drop a little white glue into the holes and replace the caps. When you buy new felt pens, simply discard the new caps.

*How To Proceed:*  As with crayons, offer felt pens with a variety of paper cut into different shapes.

*Variations:*  Provide heavy, slick paper, tag-like manila folders, for example. Wet the paper lightly with a brush or sponge dipped into water and have the children lightly tap the felt pens in different spots. The color will flare out, and the result looks like freeform flowers or Fourth of July sparklers.

*Traps:*  Do one before the children arrive in order to feel the wetness you need on the paper. Felt pens must be tapped gently, or the tips will disappear into the base of the pens. We have found tweezers handy for pulling them out.

---

## chalk

Regular blackboard chalk should be available at all times, and, of course, you'll need a blackboard. If you don't have sufficient wall space for blackboards, buy four or five small, wooden-framed blackboards or old-fashioned slates. We have cement floors at our school, and we provide chalk and let the children draw right on the floor. We talk, of course, about the kind of floor it is and that we can't do this at home. We also draw with chalk on our patio play area with the same set of cautions to the children.

## colored art chalk

This chalk comes in beautiful colors and is available at most school and art supply houses. It's softer than blackboard chalk and breaks easily. We talk about this problem, but we don't make a fuss about breakage.

*What You'll Need:*  Colored art chalk; fixer (liquid starch or buttermilk); heavy-duty paper.

*How To Proceed:*  This chalk can be used to draw with, like crayons, but it is powdery and rubs off, so you'll need the fixer. Have the child brush liquid starch on a piece of heavy paper, like construction paper, and then draw with the chalk. Buttermilk can also be used as a fixer, but some children dislike the smell.

*Variations:*  Provide paper and have the child brush the fixer (starch or buttermilk) on the paper. Then place the chalk on its side and rub.

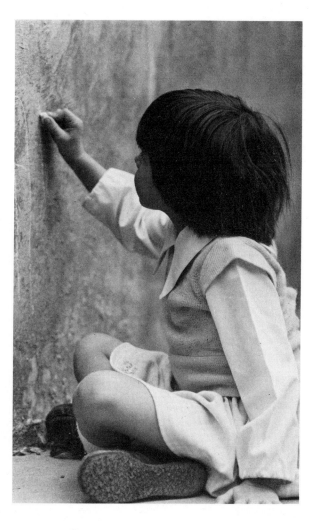

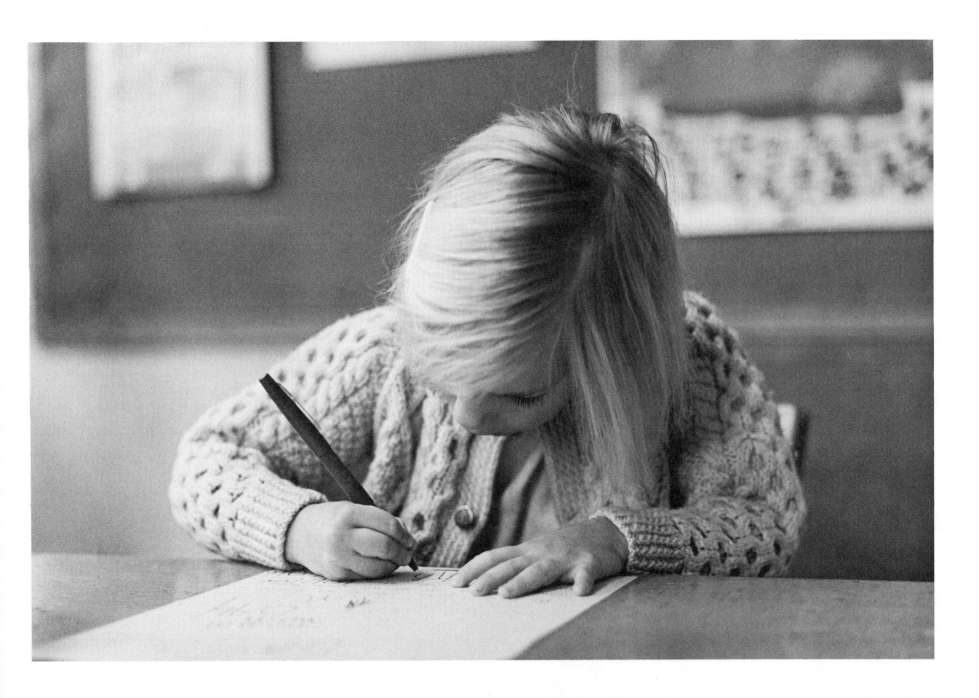

# printing

I use the term printing to describe two quite different processes: (1) using objects dipped in paint to form a repeating pattern on paper and (2) placing a blank piece of paper on a prepared surface, pressing, and removing—thus lifting a print from the surface. Printing—in either way it's done—by printing with objects or by "taking a print" from a surface—is a new experience for young children, and they delight in discovering the results.

## dipping and printing

*What You'll Need:* Liquid tempera in a shallow pan; a variety of papers; an object from the list that follows or a similar object. Objects to print with are everywhere; you should be constantly searching for new ones to add to this list: corks, cookie cutters, plastic blocks, pieces of wood, thread spools, pieces of styrofoam.

*How To Proceed:* Present the materials and let the children dip and print.

*Variations:* Vary the color of the paint and the color and kind of paper. One day we dipped plastic snowflakes in white paint and painted on black paper. The results were stunning.

## fingerpaint printing

See Chapter 3, fingerpainting, p. 28, for details.

## potato prints

They say that people who seem to do things the easy way have been doing things the hard way for a long time and for that reason find a simpler method. For years I struggled with potato prints, working carefully to carve a design in the potato, only to ruin it on the last cut. I finally discovered an easier way.

*What You'll Need:* A large potato for each two children; a cookie cutter; a sharp knife; a pie pan; liquid tempera; paper toweling; paper suitable to print on.

*How To Proceed:* Fold the toweling into several thicknesses and place in the bottom of the pie pan. Pour paint over it to make a print pad. Cut the potato in half. On the cut side, press a small cookie cutter into the potato and cut around it with a knife. When you pull the cutter out, you will have a perfect design. Have the children press the potato onto the print pad and then onto paper.

*Variations:* Vary paper. Use holiday cookie cutters. Use different colors of paint.

## printing from melted crayons

See Chapter 4, melted crayon art, p. 44, for details.

## printing from styrofoam trays

*What You'll Need:*  Meat trays, 5x7 inches, *smooth* on the bottom; small metal cookie cutters; waterbase linoleum block ink; a brayer (small art roller); paper — tissue or typing paper.

*How To Proceed:*  With a small metal cookie cutter, make a design in the bottom of the meat tray, taking care not to push the cutter all the way through. In a second meat tray or pie pan, put a little linoleum block ink. Rub a brayer in the paint until the roller is covered. Roll the brayer in the first tray over the design. Place a piece of paper over the inked design, rub lightly, remove, and you'll have a print.

*Variations:*  Provide a meat tray for each child and have the child draw in the design with a dull pencil. Proceed as above.

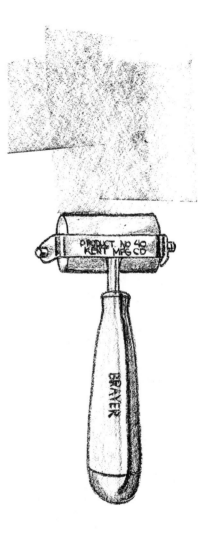

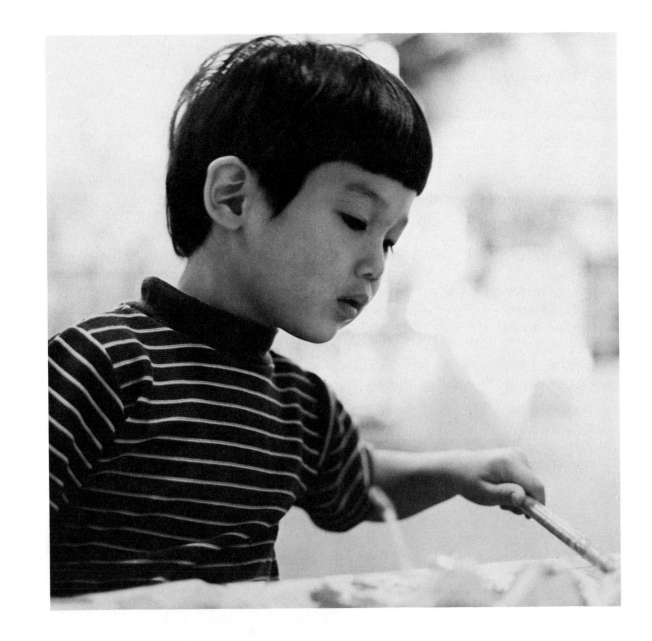

# collages

We do collages at our school once a week, and every child produces at least one. There is never a right way or a wrong way to do a collage: collages are highly creative; each child's product is different, and they are excellent experience with the abstract.

We have a collection of large plastic boxes, the kind used for storing sewing accessories or sold in notion departments as closet storage boxes. Each box contains a different theme, color, or shape. We have boxes for all basic colors, including silver and gold, boxes for shapes—one for freeform shapes, another for circles, still another for triangles. These shapes are also present in other collections—the collections of different kinds of materials, for example—plastic, lace, ribbon, leather. Another box is filled with pieces of tissue paper, yet another with rickrack.

*What You'll Need:* Meat trays; collage collections; glue in small containers; cardboard or heavy paper, cut 8x10 inches or smaller.

COLLAGE SET-UP

Child takes tray from stack then walks arnd. table & selects materials

Put out 6 or 8 glue bottles

ART TABLE

48"

Stack of empty meat trays

MATERIALS TABLE

Put out 7 or 8 meat trays with different collage materials in each tray

Divide collage materials in trays so children can see all materials available. Examples: Put buttons & sequins in one tray, construction paper scraps & tissue paper in another. yarn, string, wallpaper, carpet, stick-on stars etc. Child does collage on art table.

*How To Proceed:* On the extra art table, set eight to nine meat trays around the table and, last, a stack of empty meat trays. For some of the collages you will need only one or two boxes from your own collection; for others, you may need to check through virtually every collection you have in your closet. From your collage boxes, separate the items to be used. In one tray put buttons; in another, sequins; in another, "sticky dots"; in another, scrap material.

Have the children take empty trays and collect from the filled trays whatever they'd like to use on their collages. When they've finished with their collecting, have them proceed to the regular art table, where you've placed six or seven small containers of glue and cardboard or heavy paper pieces, where they may glue the objects on in any design.

*Variations:* The joy of the collage is that the variations are endless. After reading the list, you'll think of your own collage favorites and wonder why I left them off. I have put this list into the order in which I would present the collages weekly through a school year beginning in September—thus orange before Halloween, for example.

(1) *Circles:* Think of variety—sticky dots, buttons, plastic, metal, fabric, wallpaper.
(2) *Red:* Paper, plastic, buttons.
(3) *Yellow.*
(4) *Rectangles.*
(5) *Orange.*
(6) *Halloween:* Cutouts from wrapping paper, stickers, orange and black paper, pumpkin seeds.
(7) *Fall:* Dry moss, acorns, leaves, twigs. Go for a collage walk!
(8) *Blue.*
(9) *Brown.*
(10) *Thanksgiving:* Collage of stickers, browns, gold ribbon; collage of cutout magazine pictures of all kinds—food, people, other things children are thankful for.
(11) *Triangles.*
(12) *Green.*
(13) *Christmas.*
(14) *Shiny:* Foil, cellophane, sequins.
(15) *White.*
(16) *Winter:* Pictures, stickers.
(17) *Paper:* Newspaper pieces, wallpaper, construction paper.
(18) *Purple.*
(19) *Patriotic:* Lincoln, Washington, red, white, and blue.
(20) *Valentine's Day:* Hearts of every material.
(21) *Leather scraps.*
(22) *Plastic.*
(23) *Sewing:* Rickrack, thread, bias tape, yarn, ribbon.

(24) *Fabric:* Muslin, gauze, corduroy, drapery samples, velvet.
(25) *Quiet:* Have children choose magazine pictures.
(26) *Noisy.*
(27) *Day.*
(28) *Night.*
(29) *Spring.*
(30) *Leftovers:* Use scraps of all kinds left from other projects.

# holidays

Children and parents like ''art'' to hang up for the holidays. Holidays are important in our culture; we make a production of Halloween, Thanksgiving, Mother's Day, Father's Day. Holiday art can be a trap for both children and teachers. The trap, as I see it, is that teachers, in wanting to send home holiday art, get ''craft'' ideas, which are usually much too difficult for the young child to execute successfully. To solve the problem of difficulty, the teacher then makes a model for the child to look at—the ditto of a turkey, for example, that children must cut and color and paste exactly like the model the teacher has presented.

There may be holidays you celebrate that I won't comment on in this section. What I hope to do here is to give you a feeling of how to accomplish holiday art. Think about any of the projects set out in this book and realize that almost any of them

can be done for holidays by using different shapes of paper, special colors of paint, crayons, or felt pens. This will give you beautiful things to send home, things for parents to hang up, without pressuring the child or, worse, having to do most of the art yourself.

Even during holidays, we must think developmentally about children and art. There are children in every school who won't want to get involved with holiday art. Be sure to provide alternate shapes and a variety of other colors for them.

## halloween

*Easel Art:* Cut pumpkin shapes; offer orange paint the first week, other colors like black, green, and purple for delightfully weird pumpkins during the second week. Cut out a ghost shape for the easel.

*Table Top Art:* Cut simple Halloween shapes. Offer them with the tempera paint, felt pens, or crayons.

*Marble Painting:* Cut pumpkin shapes, place papers in the box, and use marbles with orange and black paint. Use orange paper with black paint or black with orange.

*Hot Tray Art:* Cut Halloween shapes and provide a variety of crayons to melt. If you prefer, of course, use only orange and black.

*Fingerpainting:* Mask off an area on the table top. Using finger painting "goop" or liquid starch with orange or black paint, have the children fingerpaint and then remove the painting with appropriately shaped paper when the children are finished.

*Cut and Color:* Halloween shapes can be presented with scraps of construction paper to be torn or glued if the children want to make faces or simply decorate.

*"Thing" Painting:* Halloween shapes in paper can be presented with "things" to paint with. Remember that imagination is the key here: sponges, egg whips, feather dusters, chains. "Thing" painting should be a several-day art project in the sense that you will not present all the objects to paint with on the first day.

*Sponge Painting:* Cut sponges into pumpkins or witches and dip into paint and press onto paper.

## thanksgiving

Shapes for Thanksgiving are difficult because pilgrims, ships and turkeys take time to cut. Allow ample time for cutting papers for this holiday.

*Finger Turkeys:* You'll need brown paint in one pan, red paint in another, and paper. Have the child dip one hand into the brown paint. Then slide the hand onto the edge of the paint pan to remove the excess. Press the hand onto the paper and tell the child to wiggle the fingers of that hand a little. The result will look like a turkey. Then have the child dip the index finger of the other hand into red paint and add the wattle under the turkey's chin by pressing the index finger at the base of the opposite thumb.

*Thanksgiving Collage:* Provide lots of pictures cut out of magazines—food, toys, men, women, objects. Have the child make a collage of the pictures chosen to be thankful for.

*Sponge Painting:* Cut sponges into turkey shapes. This is a good time of the year to present brown tempera paint.

## christmas

There is so much going on all over during this season that the calmer it is at school, the better for the child and the teacher. At our school, we are careful not to start holiday art until December 5 or 6.

*Easel Art:* Cut big trees, bells for the easels.

*Table Top Art:* Cut tree shapes and present them in many ways with small scraps of construction paper to be glued. Present the trees with sponges cut into circular and square shapes and the result will look like ornamented trees.

*Sponge Painting:* Cut sponges into tree shapes. Children never tire of sponge painting, especially if you vary the shape of the sponge.

*Melted Crayon Art:* Cut small trees or bells out of a variety of papers to remove prints from the foil. Onionskin paper and those beautiful metallic crayons make trees that will look like stained glass.

*Large Christmas Trees:* Sometimes we cut a big tree, and as many children as want to do so participate in the project; they paint it, or they use "sticky dots" to decorate it or print it with shaped sponges. You can cut two big trees, and when you've finished decorating both, staple both sides together, starting from the top. Before you staple the bottom, stuff the tree with crumpled newspapers. Hang it from the ceiling. The children will love it.

*Glitter and Glue:*  Christmas shapes can be presented with glitter and mucilage. Children who are able to cut shapes can begin with that activity — trees, bells, stars. Yarn can be dipped into glue that has been thinned with a little water, dropped in any shape onto waxed paper, and finally sprinkled with glitter. When dried and removed from the waxed paper, these make good tree decorations.

*Card Rubbings:*  Remember that it's better for you to hold down the paper when children are rubbing so that it doesn't slide. Place Christmas cards with embossed pictures on the art table and cover them with paper. Rub, with the side of a crayon, until the picture appears. Be sure to praise not the picture, but rather the technique.

*Chain Craft:*  I don't consider chain making an art, but a craft. Chains have been made by children since time began, however, and paper chains are a good tree decoration at Christmas. Many two to four-year-olds have difficulty getting these chains together without close supervision. Use strips of paper an inch and one-half wide and seven to eight inches long. I like the long strips because it doesn't take many to make an impressive chain. Remember the concept of "instant" results for young children.

*Traps:*  Try not to fall into the "craft" trap at Christmas. "Craft" Santas are a prime example of adult-oriented art. They look very good in the art books, but there's very little satisfaction for the child in this kind of activity. In fact, the pressure to produce a standard Santa is much too frustrating for young children and only adds to holiday tension. Finally, don't fail to provide for the child who needs freeform shapes rather than Christmas trees or bells. Children need freedom to work in their own way this season as in any other!

## valentine's day

By now, I sound repetitious, I'm sure, but I can't stress this point often enough. Do the holiday with shapes and colors. Go with all the art projects presented in this book. Just change the shape of the paper to hearts.

*Easel Art:*  Cut large hearts. You might want to try negative-space art and cut a small heart or two out of the center of a larger one.

*Table Top Art:*  Use hearts cut out of all kinds of paper. Scrap paper and "sticky dots" are wonderful because the children can make their own Valentines.

*Sponge Art:*  Cut sponges into appropriate shapes and use with red or pink liquid tempera.

*Melted Crayon Art:*  Use heart-shaped paper. The silver crayons, mixed with red and pink, are beautiful on onionskin paper hearts.

*Cut and Color:*  On an extra table, you can put hearts cut out of any kind of paper along with scissors, hole punches, transparent tape, and scraps of colored paper.

*Collages:*  For Valentine's Day put out red paper, doilies, lace, red and pink fabric, rickrack, red buttons, ribbon.

## easter

*Easel Art:* Use egg-shaped easel paper. Cut some with negative space in mind.

*Sponge Printing:* Cut sponges into egg shapes. Many colors of liquid tempera can be used.

*"Thing" Art:* Cut egg shapes and paint with "things."

*Fingerpainting:* Do tabletop fingerpainting and remove the results with egg-shaped paper.

*Collages:* Use all sorts of pastel paper, tissue, lace for collage day. Wallpaper scraps are nice. We use wrapping paper with appropriate holiday designs. Just cut it up.

*Easter Hats:* This Easter hat project is one of the few two-day projects we do at our school. What you'll need on the first day is two pieces of wallpaper, 18 inches square, for each child; wheat wallpaper paste mixed according to the directions; several brushes; a piece of heavy string, 12 to 14 inches long, for each child; feathers, ribbons, crepe paper, scraps, and yarn. Have each child pick two pieces of wallpaper and then spread the wheat paste onto the back of each piece and press the pieces together back to back. Now press the paper onto the child's head and shape as desired, twisting rolls and brims as you work. Tie a string around the crown, remove carefully, and place on a flat surface to dry. Dry overnight and the next day have the children decorate with the materials mentioned in the list.

mother's day
father's day

Just like Christmas, Mother's Day and Father's Day are times we get trapped into doing "crafts" that are too difficult for young children and often very expensive.

A month before Mother's Day or Father's Day, I take a pad of paper, and during the children's free time, I capture each child and ask, "What is a mother? What does she do? What's the best thing she does? What does she look like?" I rewrite the notes on plain white paper and make a construction paper cover, on which the child draws a picture.

I suggest they draw their mothers or fathers, but if they say they can't, I ask them to draw a picture they think their mother or father would like. This gift is an absolute joy to parents. I've seen parents extremely touched by the delightful things their children say.

Be very careful, by the way, not to lead the children into answers. Ask basic questions and don't look for "cute" answers. You can vary this project, if you need to, for grandparents, brothers and sisters.

# special art

I use the term *special art* to describe art projects we do only once or twice a year. Sometimes expense is the limiting factor for these projects. In most cases, however, I use these activities only infrequently because adults must be actively involved in them, and adult participation limits children's creativity.

---

blueprint art

---

A "magic" art and one which takes a great deal of supervision, this art requires first that you find blueprint paper. It's not expensive and is available retail at most blueprint companies. They'll usually give it to you in a black plastic tube. Don't expose the paper to the sun; keep it in the container until you're ready to use it.

*What You'll Need:* Blueprint paper in 12-inch squares, one or two pieces for each child; a piece of wood larger than the paper; objects to place on the paper—scissors, wooden letters, flowers, leaves; a gallon jar; one-half cup household ammonia.

*How To Proceed:* Put the ammonia into the jar and replace the lid. Place a piece of blueprint paper onto the wood. Then have the child put objects on the paper. When the paper has been arranged to the child's satisfaction, carry the wood with paper and objects out into the sun and expose it for ten to fifteen seconds. Bring the arrangement inside, remove the objects, and roll up the paper, finally placing it in the jar. The paper needn't touch the ammonia, although it won't hurt if it does. The fumes do the developing trick in less than a minute.

*Comments:* The children really love this art, but you can tell from the description that there's a lot of adult participation necessary—more than I'm comfortable with in daily art activities. Be careful that no child gets too near the ammonia jar.

## books

We do "books" at our school primarily for their language development function, but because the story in the "book" is about a picture drawn by the child, I think this activity qualifies as art as well.

*What You'll Need:* Five or six pieces of newsprint or computer paper for each book; felt pen or crayons; stapler.

*How To Proceed:* Staple the paper on one side so it looks like a book; the pages should be about 16x18 inches. Have the child draw a picture on the inside of the cover. Then ask the child to tell the story that goes with that picture and have an adult write it down on the page opposite. Proceed until the book is finished. The first page may take a little extra encouragement, but once the children get the idea, they love it.

*Comments:* We read the "books" written by the children during story time.

*Variations:* Have children pick out cards they like, glue them in, and tell the story that goes with them. Holiday or greeting cards of any theme can be collected and used for this project, although if you use this variation, note that you are eliminating the art component and concentrating entirely on the project as language development.

## dip and dye

*What You'll Need:* Several four-ounce bottles of food coloring; nine-inch pie pans; cold water; paper toweling.

*How To Proceed:* Into three or four pans, pour the food coloring, a different color for each pan. Add about a cup of cold water to each; the dye needs to be strong for a bright finished product. Fold, into any shape, plain paper toweling—white the first day of the project, then yellow, green, or blue; then fold again, several times. Have the child dip the corners of the multi-folded towel into each pan of dye. This is a crucial step: just a second in the dye is enough. Gentle guidance with the first one is necessary. Then have the child dip another corner of the folded towel into another color. The results are beautifully bright, irregular patterns on paper towels.

photograph by anita rossovich

*Variations:* Some kinds of paper coffee filters are prefolded and open into a flat circle. Sturdy and fun to use once for this project, they are rather expensive. I do use them once a year, however.

*Traps:* Fold, or have children fold, lots of towels; everyone wants to do dozens. When children dip too long, the towel gets soaked, leaving no place for a name, so an adult needs to be on hand with guidance. Use towels strong enough so they won't disintegrate when wet.

## "fainting" necklaces

We had done this art early in the year—in November, perhaps—and one day in February, Jonathan said, "Teacher, please let's do those things that faint." At a loss as to what he meant, I asked him to remind me how we did it, and he answered, "Oh, you know. We cut up that stuff, draw on it, and then we put it in the oven, and it faints."

*What You'll Need:* Sheets of any heavy plastic; permanent felt pens; an oven; aluminum foil; a cookie sheet; colored yarn.

*How To Proceed:* Cut the plastic into six-inch pieces of any shape. Let children draw on the pieces of plastic with the permanent-ink felt pens. Punch a hole in one end of each plastic for yarn. Don't attach the yarn yet. Place the plastic on a foil-covered cookie sheet, and heat in a moderate oven until it "faints." Heavier plastic curls up and makes interesting shapes; some of the lighter-weight plastics will simply shrink. Remove from the oven and let cool. String the pendants on yarn, and the children will love wearing them.

*Variations:* Place plastic drinking glasses upside down on the cookie sheet, cover with foil, and tap with a hammer to crack. Place in oven, and when they're done, there will be a hole to string the yarn through.

---

## magazine art

---

*What You'll Need:* Eyes, noses, mouths, cut out of magazines. The bigger the features, the better.

*How To Proceed:* On a large piece of paper (14x16 inches or bigger) paste or glue one set of features—eyes or nose or mouth. Present the paper with crayons or with felt pens and ask children to finish the pictures.

*Comments:* If they don't complete the picture, but are happy with what they've done, don't comment. Many times we think children won't learn unless we "teach." They'll learn, given time, experience, and encouragement.

*Traps:* Be sure to keep the eyes in pairs or your preparation time for this project will be considerably longer than otherwise necessary.

## rings

Children love rings and necklaces, anything they can use to adorn themselves.

*What You'll Need:*  Bright colored pipecleaners, cut into two-inch lengths; buttons.

*How To Proceed:*  Have the children pick out the color they would like in a pipecleaner and then have them select a button. Have each child push the pipecleaner through the hole or holes in the button. Place the ring on the child's finger and twist.

## screenpainting

I'd always tried screenpainting using the handheld, masked-off screens. I never succeeded with it until it dawned on me that very young children need a specially built frame sturdy enough to avoid the necessity of using each hand to do something different.

The screen must be built to stand off the ground. Build an 18x18 or 18x24 inch frame of 1x3's or 1x4's. Cut a piece of ordinary door or window screen one-half inch larger than the frame on both sides. Folding the edges of the screen under, tack or staple the screen to the top of the frame.

*What You'll Need:*  A framed screen; thin liquid tempera in a pie pan; a stiff toothbrush; paper cut larger than the screen; objects to arrange under the screen—scissors, cookie cutters, a comb, flowers, leaves.

*How To Proceed:* Place the paper on a flat surface. Have the child arrange objects on the paper. When the child is pleased with the pattern, place the frame, screen side up, over the paper. Have the child dip the toothbrush in paint and brush the paint through the surface of the screen, back and forth until the paper is well spattered. Remove the frame and have the child remove the objects from the paper.

## sewing cards

*What You'll Need:* Cardboard frames, six inches square; burlap cut to the same size; stapler, needlepoint needles; yarn in a variety of colors.

*How To Proceed:* Staple the burlap onto the frame, which you have cut with a utility knife. Give each child a frame and a needle that has been threaded with yarn. Show the child how to start from underneath, and gently guide a few stiches.

*Comments:* Some young children never master the notion of sewing and will sew endlessly around the frame, but as long as they're happy I don't comment.

*Variations:* Heavy materials like upholstery fabric are fine in place of burlap. You can also present buttons or cut pieces of plastic straws to sew onto the fabric.

## sun painting

There is a special, sun-sensitive paint available in hobby shops and art supply stores. I buy four or five colors. The paint comes in a great variety of colors and goes a long way.

*What You'll Need:* Sun-sensitive paint; margarine cartons, carefully labeled as to color; brushes, one for each carton; squares of white muslin or white T-shirts.

*How To Proceed:* Pour a little paint of each color into the margarine cartons. Label each carton carefully, since all of the paint looks like the same color before it's exposed to the sun. Once painted and exposed, the paint is permanent, so paint on a piece of muslin or on a plain white T-shirt. After the child has finished painting, take the fabric outside, and the paint will change from dull colors to vivid shades of red, violet, and yellow. We call it "magic" and it certainly seems that way to children.

*Comments:* This is worth the effort. Children are delighted with "magic." We do this only once or sometimes twice a year because of the expense and the unwillingness of the children to paint before the colors have changed. The first stages of this project come uncomfortably close to coercion, although the result is so good that I'm always ready to repeat sun painting the next year.

*Variations:* You can expose the paint by ironing, but the colors are not nearly so bright and the process not so "magic" for the children.

*Traps:* Because the color is not apparent to children while they paint, you must supervise so that some of each color is used, and you must watch the brushes to be sure they stay in the same container. As you supervise, talk about the "magic" that's going to happen: otherwise, no one will want to paint with all the same color.

## things to string

*What You'll Need:*  Small plastic containers; needlepoint needles; yarn; things to string—styrofoam pieces, non-sugared cereal with a hole in the middle; buttons; beads; plastic straws; paper with holes punched in the center.

*How To Proceed:*  Thread enough needles in advance so you don't have to stop to do that for each child. Set out, in four or five small plastic containers, any items from the list above. Use your imagination with the combinations of objects; we usually start with the cereal. Have the children string the objects in any order. Knot each end of the yarn and have the children tie on the necklaces!

## tie dye

Most hobby stores and art supply houses stock a dye which can be used cold. It comes in many colors; we usually purchase only one or two basic colors.

*What You'll Need:*  A six-quart plastic pail; cold dye; rubber bands; sheets or muslin in 12-inch squares; a broom handle or dowel, about 14 inches long; clothesline (optional); iron (optional); salt.

*How To Proceed:*  In a six-quart plastic pail, prepare dye as directed on package. The dye usually requires salt as a fixer, so have some on hand. Center a piece of the cloth over the pole, and have children tightly wrap five or six rubber bands,

umbrella fashion, on the material. They may need a little help. Put the stick into the dye, leaving until cloth is the desired color. Rinse very well. Remove the cloth from the pole. Hang out to dry or place it on the grass. You might want to iron it. The children love the designs on tie dye.

*Traps:* This is not an individual art; further, an adult must be there to guide and help. We do this only once a year, but we consider it worthwhile because the designs are so lovely and the process interesting. How cloth gets its color becomes apparent to the child through this experience.

# sculpture and structure

---

cooked clay

---

*What You'll Need:*  A saucepan; two cups of salt; two-thirds cup water; a cup of cornstarch; one-half cup cold water.

*How To Proceed:*  Mix the salt and two-thirds cup water in a saucepan and stir over heat for three to four minutes. Remove from the heat and add the cornstarch and remaining water. Stir until smooth. This clay won't crumble.

# Kool Clay

2½ c. floor

½ c. Salt

1 T. alum

2 pkg. kool-aid

8 1T. cooking oil.
(sometimes it works
better with a little
less cooking oil.)

1-2 c. boiling water.
(much closer to 1 cup)
than 2 cups.

Mix dry ingredients. add oil
and water. Stir quickly
mixing well, when clay cools,
knead until soft and pliable.

---

### homemade beads

*What You'll Need:*  Cooked clay; a nail; yarn.

*How To Proceed:*  Roll small balls of the cooked clay, poke a nail through, and let dry. String on the yarn.

---

### playdough #1

Playdoughs are essential in a preschool and provide hours of fun and manipulation. There are many recipes for playdough, and I've tried them all. The recipe I like best for everyday use is a simple one.

*What You'll Need:*  A saucepan; two cups flour; one cup salt; one teaspoon cream of tartar; two tablespoons oil; one teaspoon food coloring; two cups water.

*How To Proceed:*  Mix ingredients in saucepan and stirring constantly, cook over medium heat until dough leaves sides of pan. Remove from pan and knead for a few minutes.

*Comments:*  This is a very smooth, pliable clay. We store our clay in a tightly closed plastic container. Fifty children play with it every day, and it lasts for weeks. We don't find it necessary to refrigerate the mixture.

## playdough #2

*What You'll Need:*  A bowl; three cups flour; one cup salt; one cup water with coloring; one tablespoon oil.

*How To Proceed:*  Mix the flour and salt in the bowl. Add water and oil and mix. This version takes lots of mixing and kneading. Have the children help.

*Comments:*  This playdough isn't as smooth as the first and doesn't last as long.

*Variations:*  Add a bottle of vanilla, maple, or banana extract to the water. The children love the odor.

## sandcasting

*What You'll Need:*  A sandpile or several large dishpans or tubs full of sand; plaster of Paris; cold water; an assortment of shells, small stones, twigs, broken shells.

*How To Proceed:*  Have the child make an irregular impression in the sand—not larger than eight inches in diameter. Some of our children have scooped out their initials, for example. Have them put a few shells, stones, or other small objects in the impression. You can poke a few extra holes in the sand, and the casting will have interesting "bumps." After the impression is ready, mix your plaster. In an old pan or coffee can, pour about two cups of cold water and enough plaster of Paris to make the mixture thick—milkshake thickness is good. Spoon the plaster into the

sandhole to a thickness of about one and one-half inches. Sink a heavy-duty bent hairpin, leaving half exposed for a hook. Let set up for forty-five minutes to an hour. Using both hands, being careful not to break edges, scoop the casting out. Brush away the excess sand.

*Comments:* Sandcasting is worth the effort. It's not difficult. I prefer doing castings in a large sandpile because so many can be done in one day.

## styrofoam

Styrofoam comes in all shapes and sizes. Department stores pack small pieces around breakable items. Television backs are protected by large pieces of foam during shipping. We gather styrofoam and store it until we have enough for all of the children to make "masterpieces." Have small and large pieces of styrofoam available. Join with small bits of wire or white glue. It takes some time to gather enough styrofoam for a whole class of children, but alert your parents, local business, and keep your own eyes open!!

## wood

Children love to work with wood! The more variety in shape, the more fun for the child. We get scraps from cabinet makers. The pieces should be small enough to handle, but have on hand a few pieces, about twelve inches square, large enough to use as base pieces.

I put fifteen to twenty pieces of wood in the center of the art table with base pieces available and a large box of small pieces of wood on hand as a reserve. Using white glue, which holds well once it dries, the child "builds" whatever comes to mind. We've witnessed marvellous abstractions. We've seen whole cities grow. Magnificent apartment houses, dragons, boats—all these things appear from wood scraps. Some of our children paint their structures; painting should be done only after the glue has dried. Others prefer to leave their structures in a natural state.

*Comments:* My family gave me a small electric handsaw for Christmas three years ago. It's been wonderful; if you can afford one, they're a great tool to have available for parent and teacher use.

# planning

My own impulse with a new book is to want to try it all the first week. Knowing how overwhelming a book full of art ideas can be, I wanted to give some idea of how to work shapes, colors, special art into a program. The schedule that follows is not offered as something to be strictly adhered to, but as a possible order of things to give you ideas about when to try new art, how to use the collage orders I suggest. Most important, of course, are your own variations on my suggestions.

# september

*Easel Paint:* Red, yellow, blue.

*First Week:* Now is the time to introduce circles. Use circles on the easels, on the art table to color or use with felt pens. Try a circle collage.

*Second Week:* Now, try a large circle on the floor for four or five children to paint at a time. Use circles on the art table and introduce red paint. Follow through with a red collage.

*Third Week:* You might want to try finger-painting, using shaving cream on a table-top. Another day, try fingerpainting to music. Paint mixing experiences should begin. Start with red paint, following through with blue. Do a blue collage.

*Fourth Week:* Introduce a new color, with yellow. Use circles at the cut and color table with hole punches and transparent tape. Use circles on the art table to paste or glue smaller circles onto. Do a yellow collage.

# october

*Easel paint:* Red, blue, yellow, orange.

*First Week:* Move on to rectangles on the easels, and, looking toward the end of the month, introduce orange paint with sponge painting. Do a rectangle collage.

*Second Week:* This week fingerpaint with orange paint on rectangular paper. Try print art, using a leaf cookie cutter. Cut and color with rectangular papers. Do a fall collage.

*Third Week:* Use pumpkin shapes on the easel. Pumpkin-shaped papers should be used for hot tray art. Do an orange collage.

*Fourth Week:* Cut sponges into ghost and other Halloween shapes—pumpkins, witches. Think about more paint mixing: try red and yellow to reinforce your ad-diton of orange this month. Do a Halloween collage.

# november

*Easel Paint:* Red, blue, yellow, orange, brown, gold.

*First Week:* Do rectangles with brown paint. Think about introducing negative space on the easels.

*Second Week:* Try a brown string paint-ing. Cut sponges into turkey shapes and use with brown paint. Do a brown collage.

*Third Week:* Time to introduce print art with turkey cookie cutters. Do a Thanks-giving collage.

*Fourth Week:* Try utensil painting with brown and gold paint. Use a brayer for print art after pressing turkey or fall shaped cookie cutters into meat trays.

# december

*Note:* Some schools have school only two weeks in December, but parents and day care centers have children every day during this busy season, so this full calendar has been planned for them.

*Easel Paint:* Red, blue, yellow, orange, brown, gold, green.

*First Week:* Introduce triangles on the art table to be colored and painted. Try a triangle collage; Christmas trees will appear.

*Second Week:* Do triangles on the extra art table with sticky dots and felt pens. Introduce green paint. Do a green collage.

*Third Week:* Try that large stuffed tree (p. 62). Do potato prints, using holiday cookie cutters. Do a Christmas collage.

*Fourth Week:* Try drip painting, using triangular paper. For melted crayon art, use the metallic crayons with tree or bell shapes. Do a red and green collage.

# january

*First Week:* It's a cold month; use white tempera tabletop fingerpaint and remove with dark construction paper. Be sure to try plastic snowflakes dipped in white paint. Try a winter collage.

*Second Week:* Do a string painting of white paint on dark paper. Try straw painting. Introduce pennant-shaped paper. Do a white collage.

*Third Week:* Now that you've added white tempera, mix pastels. Do a gold collage.

*Fourth Week:* Don't forget paint mixing. Use your additon of white. January's a good month to do wood art.

# february

*Easel Paint:* All colors; be sure to mix white with some to make pastels.

*First Week:* Heart shapes are fun and easy to cut. Try negative space with heart shaped paper. A day collage is fun to do.

*Second Week:* Do potato prints using heart-shaped cutters. Fingerpaint with chocolate pudding. With hearts cut from wallpaper, foil, lace, and ribbon, set up a Valentine collage.

*Third Week:* Drip paintings are fun in rainy weather. Again in February, use pennant-shaped paper. A red, white, and blue collage is nice for Washington's and Lincoln's birthdays.

*Fourth Week:* Try screen painting. Be sure you cut a heart design out of a plastic lid. Think about a night collage.

# march

*Easel Paint:* All colors.

*First Week:* You must have found lots of utensils by now; paint with them. Try circles again. Children love purple: do a purple collage.

*Second Week:* Do square paper on easels, art table, hot tray. What about musical drawings? Try a quiet collage; let the children leaf through magazines for pictures.

*Third Week:* Do dip and dye with two colors. Try a noisy collage.

*Fourth Week:* Use egg shaped paper on the easel and pastel tempera. Be sure to cut egg shapes for the art table. Think about an Easter collage.

# april

*Easel paint:* All Colors.

*First Week:* Try marble painting! Art chalk is interesting to work with. Have you done a silver collage?

*Second Week:* Try painting with corks, other "things." Don't forget to cut sponges into interesting shapes; use with pastel tempera. Try a spring collage.

*Third Week:* Do the sun-sensitive painting. Be sure to fingerpaint with pastel tempera. Have you tried a tissue paper collage?

*Fourth Week:* Try foldovers with pastels. Do dip and dye with three colors. Try a materials collage.

# may

*Easel Paint:* All colors.

*First Week:* Don't forget to spatter paint outside. Do footpainting; if the weather's nice, do the footpainting outside. Try a leather scraps collage; you've had all year to save.

*Second Week:* Try blueprint art. Think about blindfold painting. Try a paper collage.

*Third Week:* Try sandcasting before the school year is over. Paint outside; attach paper to outside of building or fence. Try a "pastel" college.

*Fourth Week:* Try tie-dye; T-shirts are fun. Do a "leftovers" collage. You'll need to clean out closets and drawers at the end of the school year; use all that junk!!

# an index to projects